DOODLE JOURNAL

Race Point
PUBLISHING

"And now, I'm just trying to change the world, one sequin at a time."

—Lady Gaga

"Simplicity is the ultimate sophistication."

—Leonardo da Vinci

"The truth is outside of all fixed patterns."

—Bruce Lee

"Perfectly ordered disorder designed with a helter-skelter magnificence."

—Emily Carr

"I like the night. Without the dark,
we'd never see the stars."

—Stephenie Meyer, Twilight

30° 30° 45°

30° 45°

30°

22.5°

22.5° 90°

22.5°

22.5°

"The sight of the stars always makes me dream."

—Vincent van Gogh

"Never, never rest contented with any circle of ideas,
but always be certain that a wider one is still possible."

—Pearl Bailey

"I have come across women who did not draw mandala symbols but who danced them."

—K. Raine

"For in dreams, we enter a world that's entirely our own."

—J. K. Rowling, Harry Potter and the Prisoner of Azkaban

"We delight in the beauty of the butterfly, but rarely admit the changes it has gone through to achieve that beauty."

—Maya Angelou

"The butterfly is a flying flower,
the flower is a tethered butterfly."

—Ponce-Denis Écouchard-Lebrun

"There are always flowers for those who want to see them."

—Henri Matisse

"I decided that if I could paint that flower in a huge scale, you could not ignore its beauty."

—Georgia O'Keeffe

"Pink isn't just a color, it's an attitude!"

—Miley Cyrus

"For the great doesn't happen through impulse alone [but] is a succession of little things that are brought together."

—Vincent van Gogh

"Isn't life a series of images that change as they repeat themselves?"

—Andy Warhol

"That's the beautiful thing about being human. Things change."

—Stephenie Meyer, Twilight

"My paintings do not have a center, but depend on the same amount of interest throughout."

—Jackson Pollock

"Two people can look at the same thing and see it differently."

—Justin Bieber

"The letters are mixed up.
U and I should be together."

—Jodi Picoult, Salem Falls

"Earth laughs in flowers."

— Ralph Waldo Emerson

"Colors, like features, follow
the changes of the emotions."

—Pablo Picasso

"Life isn't about how to survive the storm,
it's about how to dance in the rain."

—Taylor Swift

"All colors are the friends of their neighbors and the lovers of their opposites."

—Marc Chagall

"Art is not what
you see, but what
you make others see."

—Edgar Degas